Life

in

Rhymes

A Poetic Adventure

About the Author

Reynold Alabre is an Entrepreneur, Accountant, Tax Consultant, Realtor, Life & Health Insurance Agent, Notary Public, Music Mogul, Poet, and most of all a Philanthropist. He has received a large amount of critical acclaim for his work in the community, including for his volunteerism and his passion to help others. He has been a part of the Joint Non-Profit program formed by several non-profit organizations in Connecticut, and was a frequent collaborator of the Fight Hunger program.

Rey attended Bassick High School in Bridgeport CT until 2004. He attended the University of Bridgeport and later transferred to Southern Connecticut State University where he obtained his bachelor degree of science in Business Administration; concentrating in Accounting. Rey gives credit to all his educators whom helped prepare him to be a professional today. He later said "I wouldn't survive in the direction I was going before I took education serious. School kept me busy and certainly kept me away from the wrong crowd."

Rey now partner with local colleges such as: the University of Bridgeport, and Sacred Heard University. He and his company provide internship opportunities and free trainings to qualified students. As part of his participation with the University of Bridgeport, he helps support their MBA in consulting program by providing students entrepreneurship ideas; help them successfully achieve and complete projects by using his company as a model.

As a Realtor, Rey helps his clients become educated on current and projected market conditions so they can make informed decisions. He develops connoisseur strategies that appeal to potential buyers. He assists clients by devising specific marketing plans and negotiates sales with the best possible financial terms. He's a member of the Business Regional Business Counsel and an expert contributor to the Chamber of Commerce Blog.

As an Accountant, Rey helps his clients save a tone of money by guiding them in their finances and by preparing their tax returns accurately. He started Rey Group, a very successful financial firm in when he was a junior in college. His firm now owns an H&R Block franchise in Bridgeport CT and is now one of the leading Tax and financial firms in the country. Rey doesn't like to advertise his company the way many companies do. He believes clients will find you as long as you're doing a good job in your community. 90% of his clients were referred to him by previous clients. He generously contributes on behalf of his business to nonprofits organizations that serve his community; such as The Connecticut Food Bank, The Bridgeport Public Library, and The Fraternal Order Police Fund. Rey is a recipient of multiple outstanding business awards such as: The Business in Bloom Award, The Mission Possible Award, The Top 100 Award, Franchisee of the Year Award, and Entrepreneur Of The Year Award.

As a former President of Service for Peace, an international service and educational non-government organization that is recognized by the United Nations, Rey recruited and encouraged local high school students to volunteer and make a difference in their community. He developed new and fun ways for those individuals to volunteer. He believes this program should be part of the school curriculum as is it essential equally for the students and the community they serve. In order to keep advocating education, Rey founded Mind is Power, a nonprofit organization which goal is to help improve education in unfortunate communities and poor countries.

Rey is a married father of two young boys. Him and his wife Nathalie love to spend time with their children. Rey believes in family values. As a very busy successful entrepreneur; when asked how he finds time to share with his family, Rey says he spends quantity time doing business, and spends quality time with his family.

Contents

School

Be-u-tifull

Cheating

New York, NY

Mermaid

Flavors

You

Way of Living

Love Time

Destiny

It's the Time

One More Time

First Love

Be

Confession

You & Me

Why?

How Would You Feel

Simple Questions

The Creator

I Love You

Indispensable

I'll Do Anything

I Fall In It

The Reciprocals of Life

Never Give Up

Think

I Am Proud

A Good Morning

Proverbs

The Fruit

Love

I Need Someone

School

By Reynold Alabre

School is the best tool
we all need to open our soul.
The best pool
to dive in to get cool
School is so cool
To be educated, oh! It feels so good.
Don't say you can't, yes you could
Don't be ignorant, don't be rude
Please don't act like a fool
Go to school

Be-u-tifull

By Reynold Alabre

Angel, that's how they used to call her
She was so simple and so beautiful
you would do anything for her

Perhaps not so secure
But I assure
you would still adore her

As the abnormal world
Changed the definition of the word
Beautiful
She began to worry
And worry
that she's not beautiful
Makeup became her best friend
She abandoned all her friends

Food was her number one enemy
Her goal was to be skinny
She became very tiny
Thinking it's sexy

She went to have all kind of plastic
surgeries so she can look chic
She would not take one single critic
From anybody even her dad Erick
She danced go-go and hip hop music
Her skin stretched like elastic

Her waist was the size of a stick
She got so sick!
She became anorexic

Cheating

By Reynold Alabre

I looked for you everywhere
couldn't find you anywhere
I have no idea where you were
but I know for sure you went somewhere
When I asked you where
you said you never went anywhere
you just went to get something over there
and your friend came to meet you there
I knew you were not here!
I knew you went somewhere!
I wish I knew who you were.
By the way, who went to meet you there?

New York, NY

By Reynold Alabre

I remember when I used
to live in New York, New York
I didn't have any money, every day
I had to walk to work
passing by the big clock
say Hi! to Mrs. Clark
by central park
Oh! that lady liked to talk and talk
she didn't like people who talk to talk
but the ones who walk to walk
Every morning she gave me two Bucks
for feeding her ducks
Her husband was struck by a truck
while driving his pickup truck
he must had bad luck;
Life don't cost a thing,
not even a buck
that's one thing I learned
in New York, New York

Mermaid

By Reynold Alabre

You look like a mermaid
I wouldn't mind being your maid
fix you some food and cool aid
I'm not worrying about getting paid
I just want to be your aid
kiss your booboo before I put the Band-Aid
don't be afraid
I'll do exactly what you said

Flavors

By Reynold Alabre

She got cherry lips
berry tongue
vanilla teeth
I like how she bites

Chocolate skin
banana hips
orange eyes
they shine like the sun

Two blueberries
two blackberries
one strawberry
they can make you go crazy

Her apple bottom
her peachy top
can lift you from the bottom
to the top

You

By Reynold Alabre

I walked eight thousand miles
to see you
I've been sitting on the tile
for a long time
waiting for you
I can't stay for a while
without you
Everything I do
is for you

Way of Living

By Reynold Alabre

You are laughing while I am crying
You are playing while I am working
You are smoking while I am thinking
remember there is a time for everything.
You are eating while I am suffering
Stealing, smoking, lying, joking
are what you do for a living
remember life is spinning.
I don't care about what people say
nothing can stop me from doing my thing
Life is interesting
and also has a meaning.

Love Time

By Reynold Alabre

Girl, I want you to be mine
You are the one I like
you can trust me that's not a lie
Please make up your mind
Let's follow the same line
I've been pleading you since I was nine
I remember it was in July
We were both in the prime time
I saw you smile
While I was drinking my wine
My first word to you was Hi!
I will never forget that night
When I told you I love your style
Than we did everything right
Now, why are you making me cry?
You know my tears will never dry
Until you tell me fine
I am ready to fight
For you and even die
I'd like to be your slave for life.

Destiny

By Reynold Alabre

I remember the first time I saw u
It was in Haiti
We were both in a Caribbean party
Drinking whiskey
That night you dressed so sexy
I called you baby
You said your name is Kelly
I told you I love your body
But you thought I was being funny
I asked you to be my lady
You said u have a two year old baby
That couldn't stop me, I'm also a daddy
Two years later we were already
a couple
And even had a couple
children. Being a family
was our destiny

It's the Time

By Reynold Alabre

It's the time to tell you
Everything I had
In my heart for you.
It's the time to tell you
How much I care about you.
It's the time to make you
Feel my emotion for you
It's the time to tell you
I love you

One More Time

By Reynold Alabre

One more time
Baby don't tell me bye-bye
Everybody makes mistakes
It's not the end of life.
Don't tell me it's over
Let's do it over.
I know I was wrong
Don't make it too long
Give it to me one more time

First Love

By Reynold Alabre

First, we were friends
Than we became lovers.
Since we were kids
We've been doing it together.
Your friends tried to stop us
Your parents tried to catch us
But we kept it up
And still drink in the same cup.

Be

By Reynold Alabre

Life is a thin line
located between two fine lines
it's up to you to follow the good line
Don't leave for tomorrow
what you can do today.
Time goes fast, so go faster.

Time gets hard
you know what you got
but you don't know what you going to get
don't try to do what others are doing
do what is good for you.
Life is a gift
but it doesn't gift.
You got to work hard
to get what u want.
Don't wait for nobody
to do something for you.
Do all you can do!
Be all you can be!
Be yourself!

Confession

By Reynold Alabre

Yeah! I know I lied to u
I made you suffer
because I had too many girls
Now, I'm here to tell u
I'm not a player no more

Yeah! I know I made you cried
I broke your heart
due to my stupidity
Now, I know your importance

It's never too late to confess
it's never too late to forgive
please! Forgive me
give me one more chance
to be with you one more time

You & Me

By Reynold Alabre

There's no roses without thorns
there's no love without hatred
there's no lifetime without mortality
every beginning has an end
there's no fun without tragedy
there's no smoke without fire
there's no me without you

Why?

By Reynold Alabre

We all have different dreams
we all have different opinions
but are all created equal
so why abusing each other?

We can have different colors
we can speak different languages
but we all smile in the same language
so, why fighting?

We can have different interests
we can have different faces
but we all have a heart
so, why killing?

How Would You Feel

By Reynold Alabre

How would you feel
if someone hurt your mother?
How would you feel
if someone hurt your father?
You like to hurt
but you don't want to get hurt.

How would you feel
if she slapped you back?
How would you feel
if she punched you back?
Don't treat people
like you don't want to be treated

Simple Questions

By Reynold Alabre

Can we still be friends
even though we broke up?
Can we still talk
even though you have another one?
Can I still call you baby
even though you aborted my baby?
Can I call you honey
when I don't have any money?
Would you mind
if I come over for some wine
and even go out sometimes?

The Creator

By Reynold Alabre

Life is a mountain
that everybody has to climb
but it's not that easy to climb it.
The only person who can make
everything easy for you
is "God".
And the only thing he needs from you is "Faith".
God is the creator
He cures me when I am sick
He blesses me
and forgives my transgressions.
He still loves me even when I offense him
He watches my steps
and spares me from dangers
He took me from the dark
and put me in the light.
"God is my creator"

I Love You

By Reynold Alabre

Girl, you are special
you look like a rose in the Eden Garden
I act like a fool every time I see you
I feel warm every time I'm close to you
I like the way you walk
the way you talk
I like the way you laugh
when I try to be funny
I like the way you smile
when I tell you "I love you"

Indispensable

By Reynold Alabre

Baby girl don't think it's over
even though you don't see me over
you are the only one
I will never leave you alone
When you're not here, it's for sure
I feel insecure
you are my star
please don't go too far
You're the best lady in town
that's why I won't let you down
I like it when you turn around
and shake that forty five pound

I'll Do Anything

By Reynold Alabre

I'll do anything
just to make you smile
I'll do anything
just to keep you in my life
I'll do anything
to make you happy
I'll do anything
to keep you safe
I'll do anything for you.
I'll always be there for you.
I'll always be with you.
I'll do anything for you.

I Fall In It

By Reynold Alabre

I fall in it
when you're talking
to me about it.
I fall in it
when you tell me
you love me.
I fall in it
when you're looking at me.
I fall in it
when you touch me.
I fall in it
when you're
smiling for me.
I fall in love
when you kiss me.

The Reciprocals of Life

By Reynold Alabre

If you try, you will find.
If you work hard, you will succeed.
If you give, you will be blessed.
If you ask, you will receive.
If you help, you will be helped.
If you work, you will be compensated.
If you respect, you will be respected.
If you're honest, you'll find honesty.
If you train well, you'll perform well.

Never Give Up

By Reynold Alabre

We are all looking
for something
don't know where to go
don't know where to find it

You might feel tired
and desperate
don't be discouraged

They don't want
to see you on top
but don't you stop

Just go!
go under, go over
go after, go around
and go through
don't ever give up

Think

By Reynold Alabre

Think before you act
Think before you make
your choices.
Think before you make a decision.
Choices have consequences
take your time to think
before you do anything
Behind your decisions
are you!

I Am Proud

By Reynold Alabre

I'm proud to be American.
I'm proud to be Haitian.
I'm proud to be African.
I'm proud to be Porto Rican.
I'm proud to be Ecuadorian.
I'm proud to be Chinese.
We must all be proud of our nationality.

A Good Morning

By Reynold Alabre

It was six o'clock
in the morning.
Children were preparing
to go to school.
Dad started working.
Mom was already in the kitchen
preparing breakfast.
The sun was shine like
it had never shone before.
The birds were chipping and playing
together while they were flying.
It was quiet outside.
The sky was beautiful;
the flowers were smelly
and attractive.
I wish that morning could last forever.

Proverbs

By Reynold Alabre

Avoiding is better than apologizing.
Don't think you are too old
or too rich to apologize.
It's never too late to learn.
Almost done its no done.
What is done is already done.
Mistake is human.
No one is smarter than anyone.
Everybody has skills.
More hands, less work.
More ideas, less problems.
It's better to start early
then rushing.
Everything that happens
has a purpose.

The Fruit

By Reynold Alabre

Why is life so short today
why is it not right
is it because of our transgressions?

Why do we suffer
why do we die
is it because of our sins?

Why do we get sick
Why can't we live everlasting
is it because of the fruit?

Love

By Reynold Alabre

We used to do it
I have never done it
before u showed me how to do it
nobody could do it
the way u do it
now, why you want to break it?
Let's have a sit
and talk about it.
Please don't tell me that's it
give it
to me a little bit.

I Need Someone

By Reynold Alabre

I need someone who can make me smile
I need someone who can make me forget how to cry
I need someone: a daily, a beauty
I need someone to share my life
I need someone who loves me…

Not for the cash
not for the cars
Not for the jewels
I need someone; a lady, a honey
I need a real one.

www.ingramcontent.com/pod-product-compliance
Lightning Source LLC
Chambersburg PA
CBHW041115180526
45172CB00001B/255